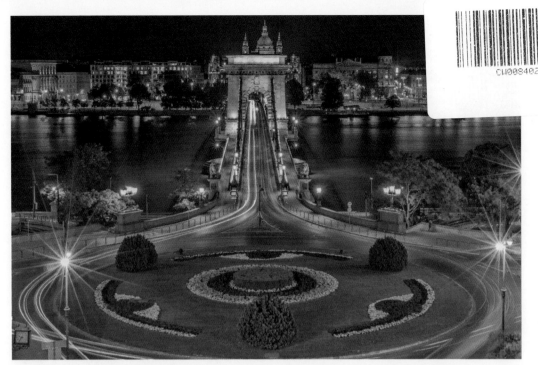

Chain Bridge at night, Budapest Hungary

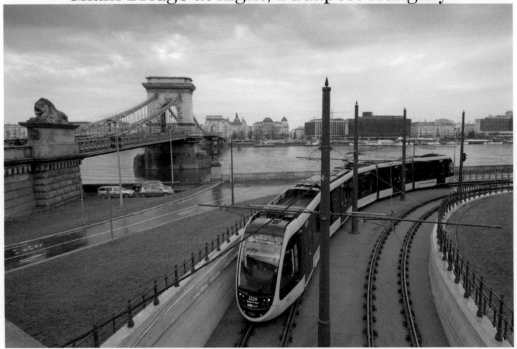

Public Tram in Budapest Hungary

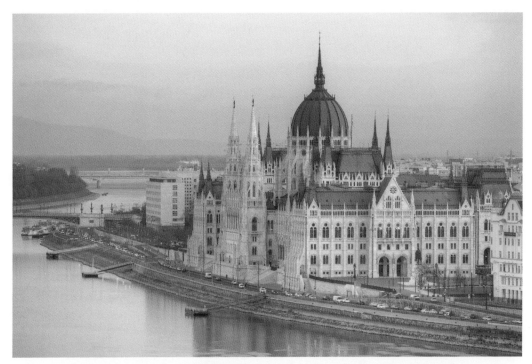

Parliament building in Budapest, Hungary

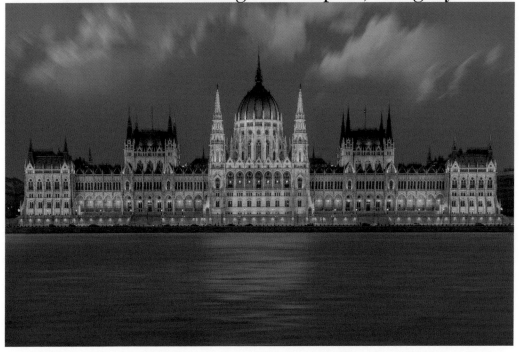

Hungary parliament building, Budapest Hungary

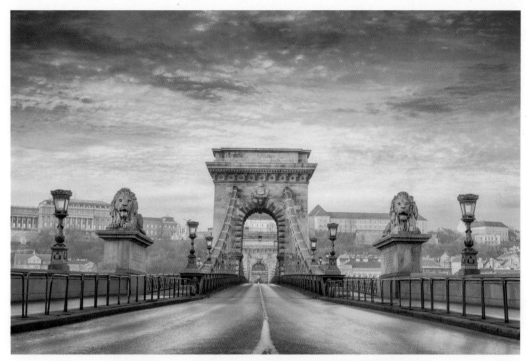

Chain bridge, Budapest Hungary

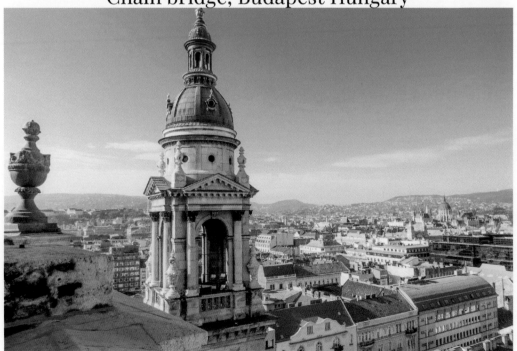

Aerial view of Budapest

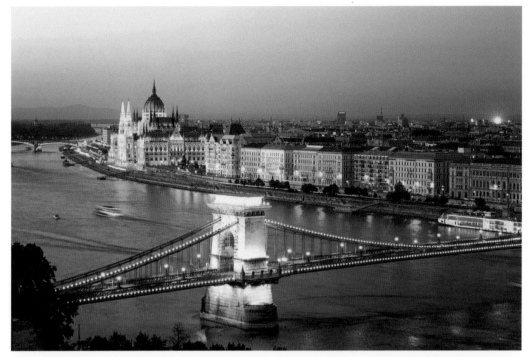

Chain bridge and Hungary Parliament at Sunset

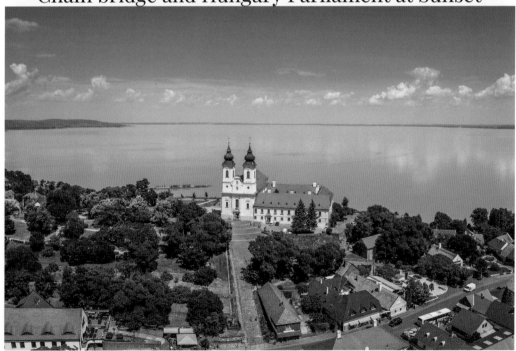

Tihany, Hungary

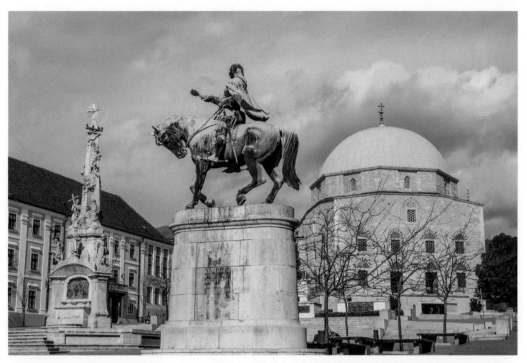

Hunyadi monument, Szechenyi Square Pecs Hungary

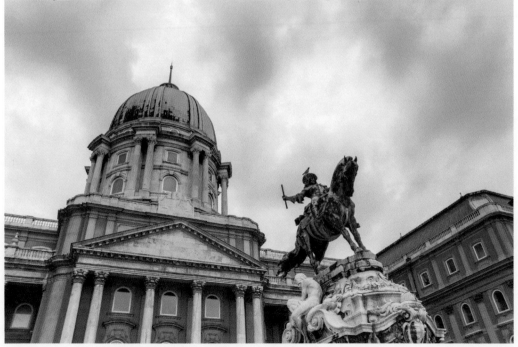

Budapest royal castle, Hungary

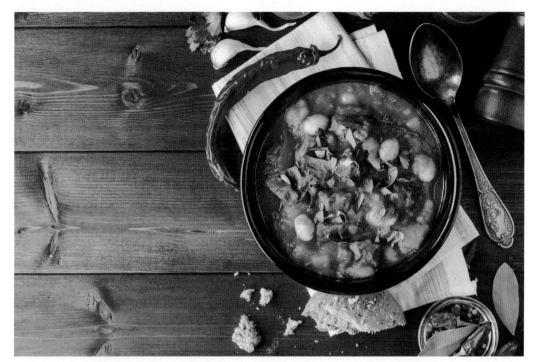

Traditional Hungarian soup, Goulash

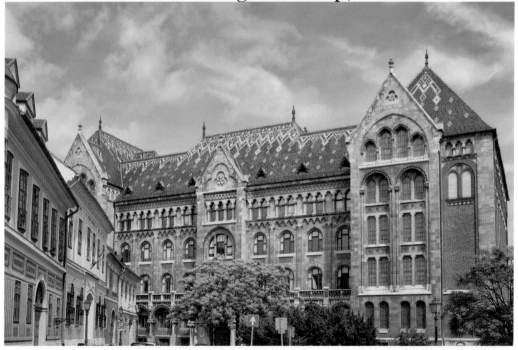

National Archives of Hungary in Budapest

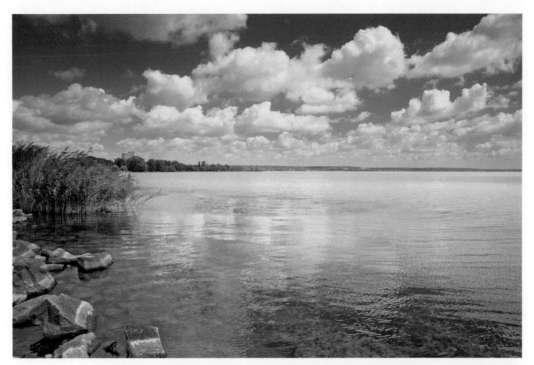

Lake balaton in summer, Hungary

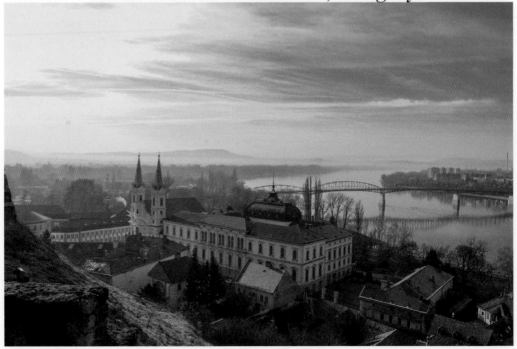

City of Budapest

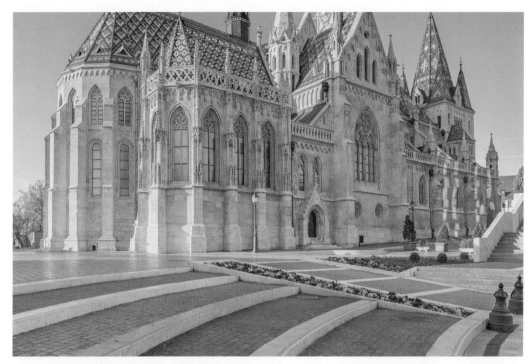

Matthias Church, Budapest Hungary

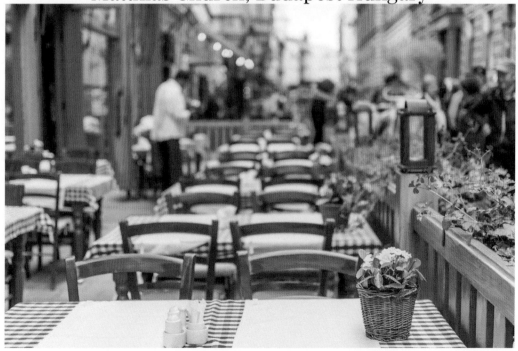

Street restaurant, Budapest Hungary

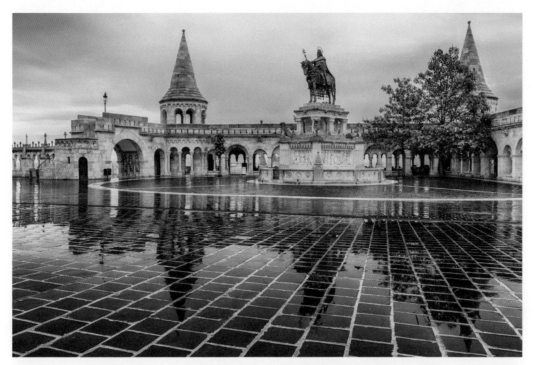

Fisherman Bastion, Budapest Hungary

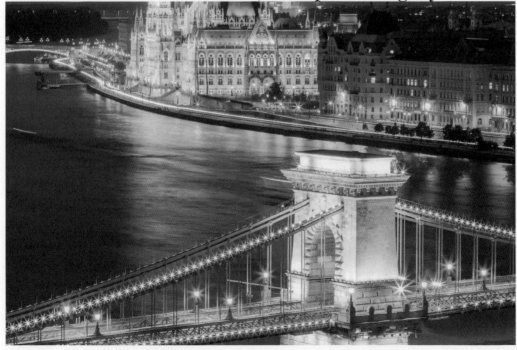

Danube river, Budapest Hungary

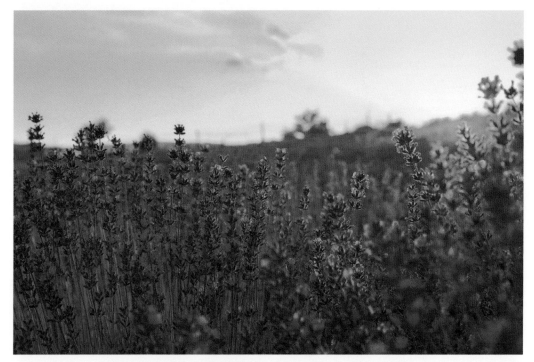

Lavender field in Tihany Hungary

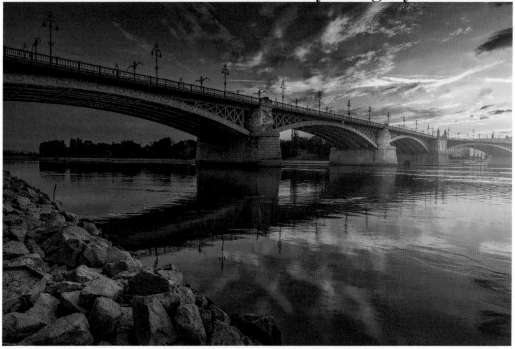

Danube Bridge at Sunset

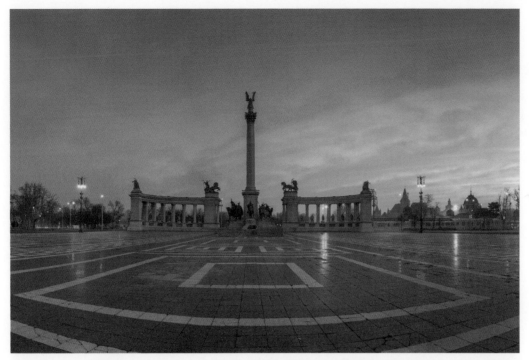

Heroes's Square, Budapest Hungary

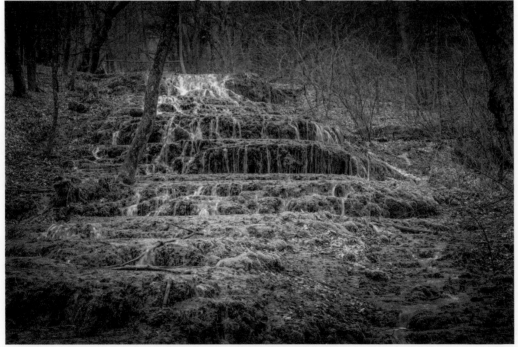

Szilvasvarad, Hungary

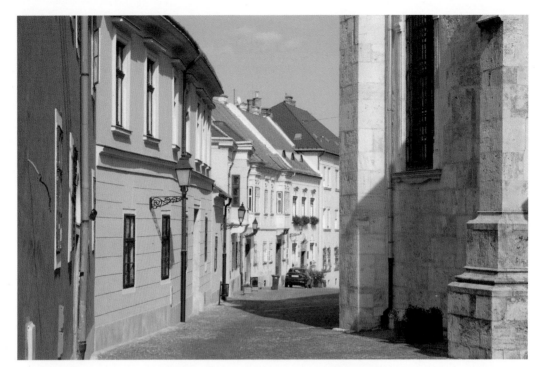

Street in Gyor, Hungary

Miskolc, Hungary

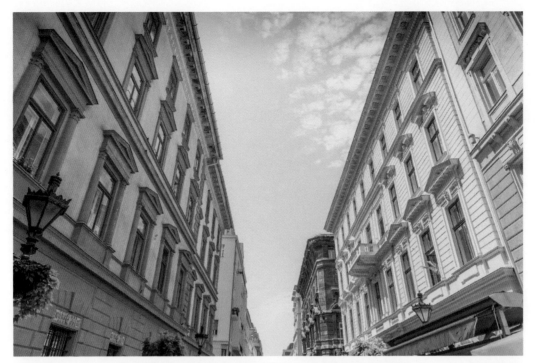

Buildings in Budapest, Hungary

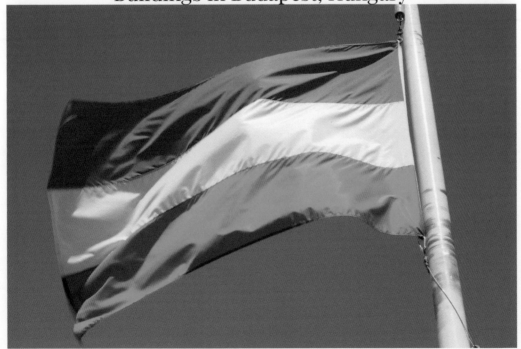

Hungary's Flag

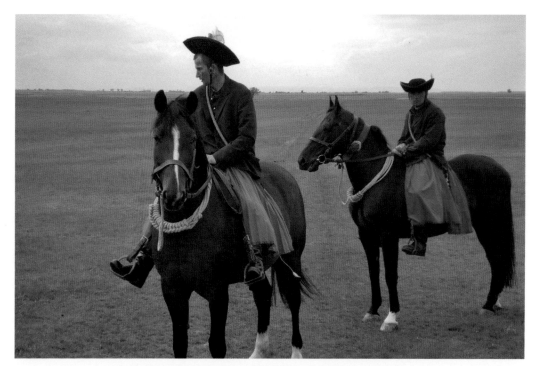

puszta horse drivers Hungary

View of Eger city Hungary

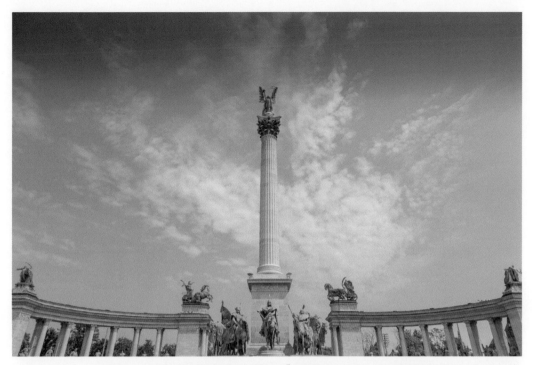

Heores Square, Budapest Hungary

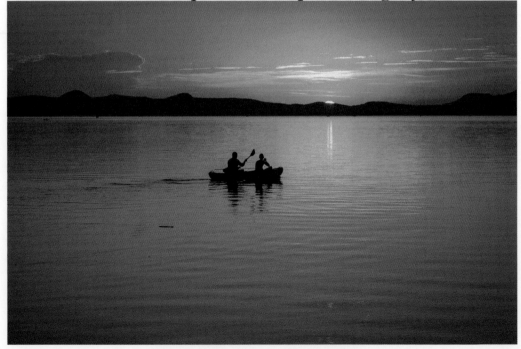

Lake Balaton Hungary

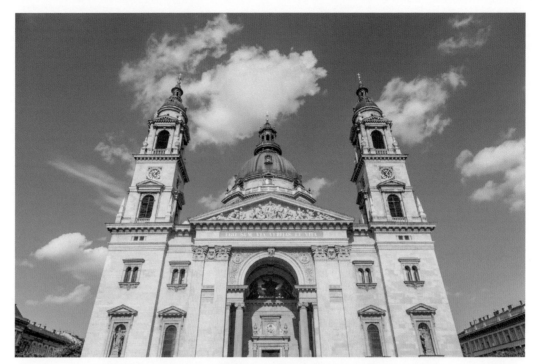

Stephen's Basillica, Budapest Hungary

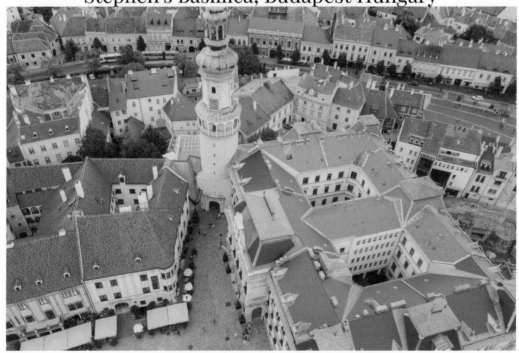

Rooftops of Sopron, Hungary

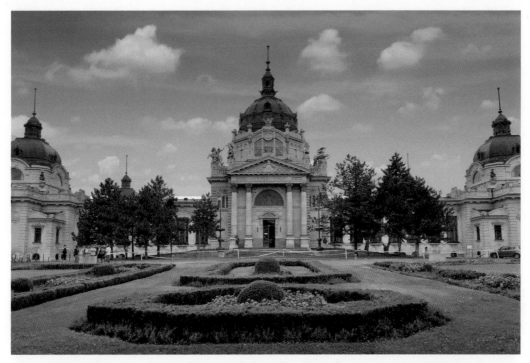

Szechenyi Medicinal bath, Budapest Hungary

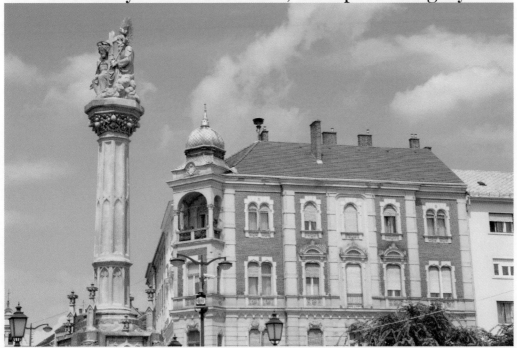

Szombathely, Hungary

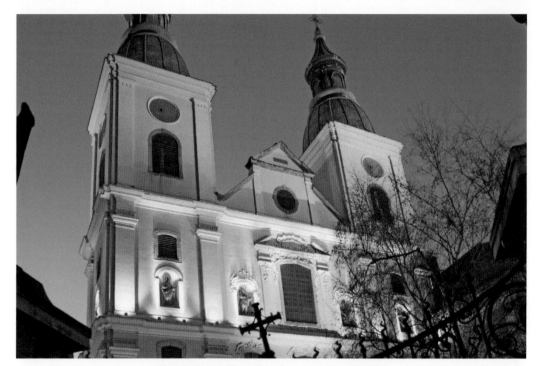

Church in Eger, Hungary

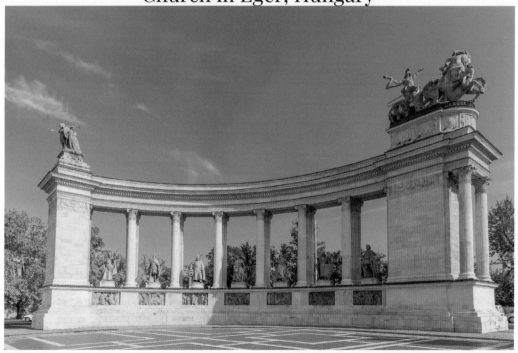

Heroes Square, Budapest Hungary

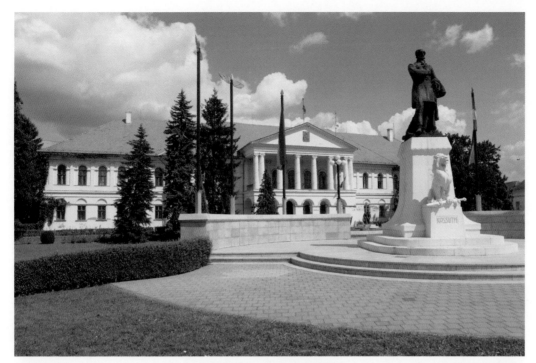

Mako, Hungary

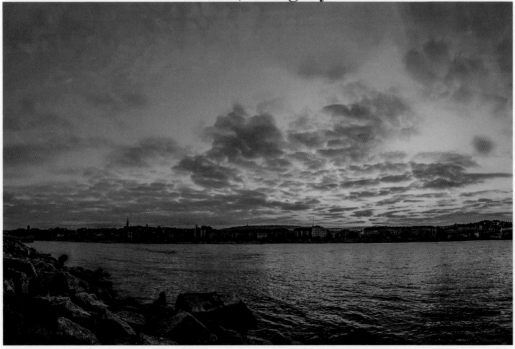

Beautiful Hungary at sunset

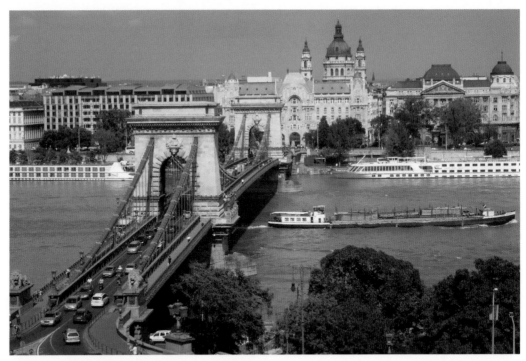

Traffic at Chain Bridge, budapest Hungary

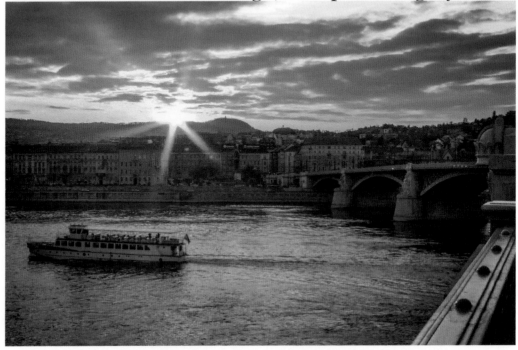

Boat on Danube river. Budapest Hungary

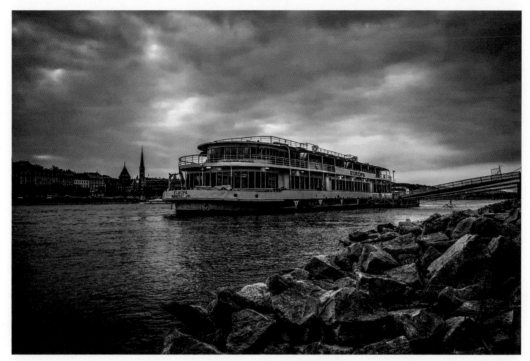

Boat at Budapest

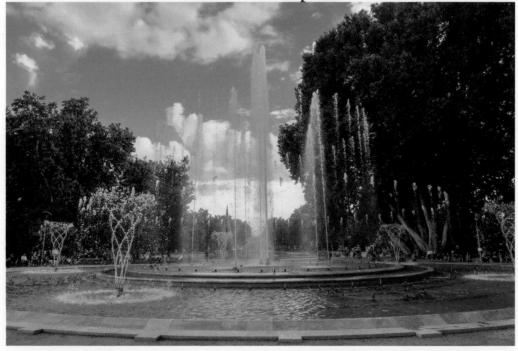

Fountain at Mageret Island, Budapest Hungary

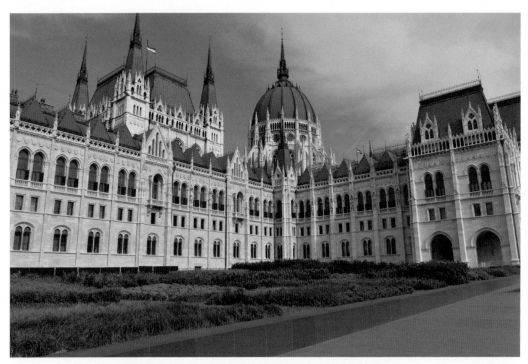

Hungary parliament, Budapest

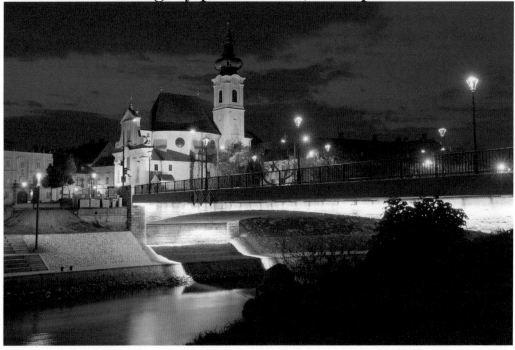

Carmelite Baroque church, Gyor Hungary

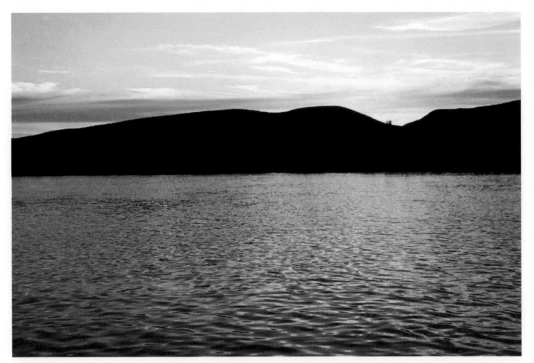

River Danube, Hungary

Spring in Hungary

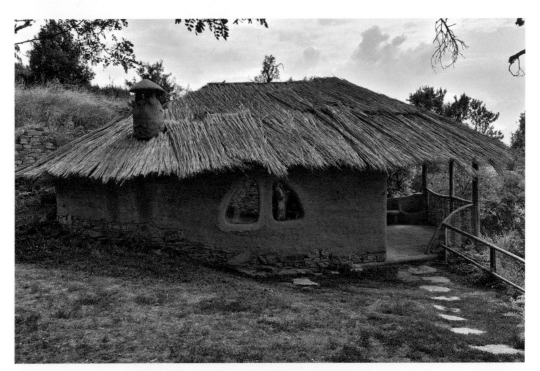

Clay house, Leshten Hungary

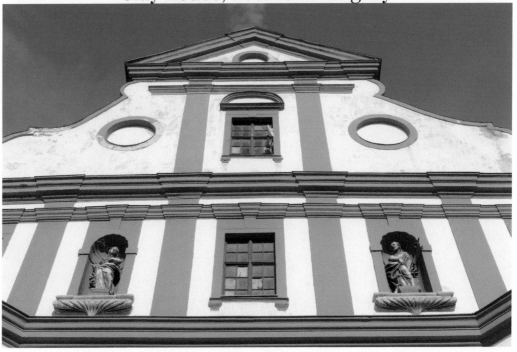

Saaint George Church, Sopron Hungary

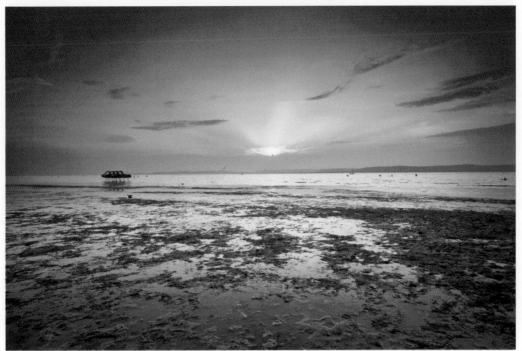

lake balaton, Hungary

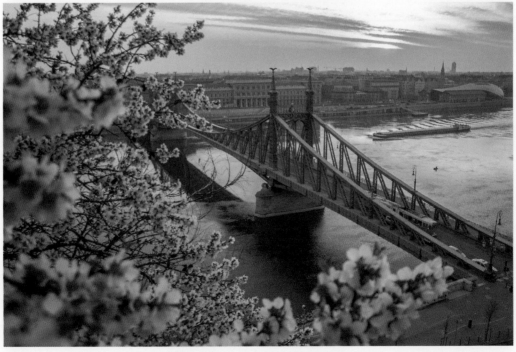

Hungary, Budapest

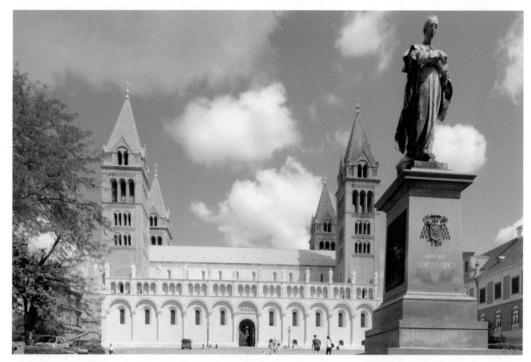

Romanesque Cathedral, Pecs Hungary

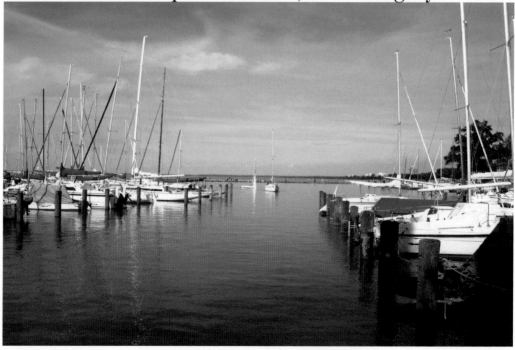

Harbor in Siofok, Hungary

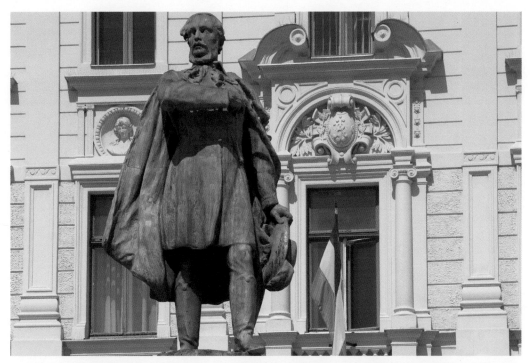

Statue of Lajos, Kossuth Pecs Hungary

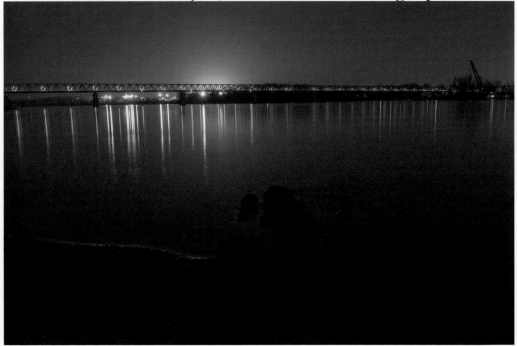

Budapest cityscape at night

Villany, Hungary

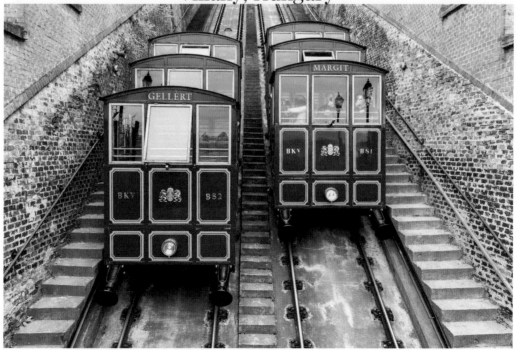

Cable car on Castle hill, Budapest Hungary

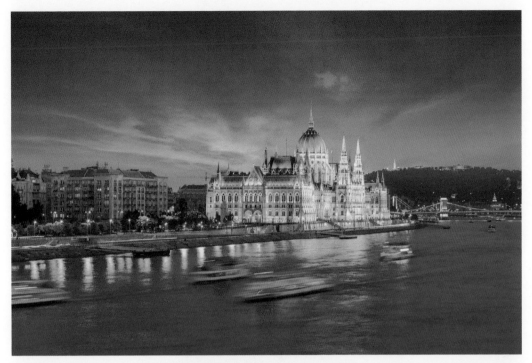

Budapest, Hungary

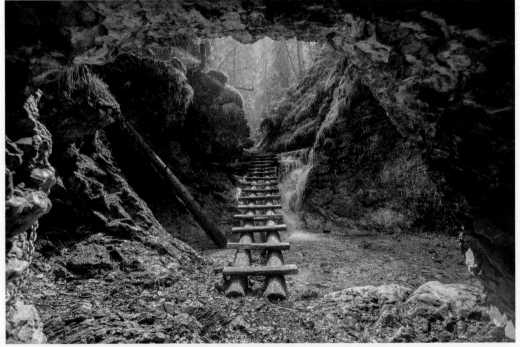

cave in Erzsebetvaros, Hungary

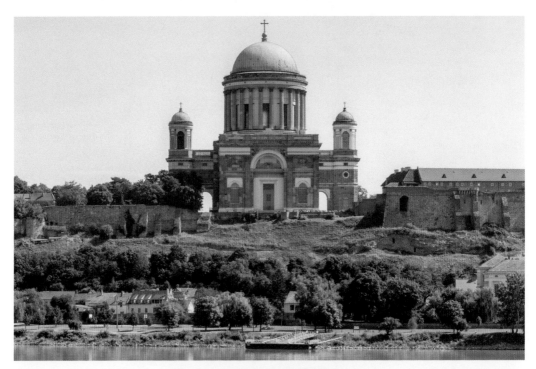

Esztergom, Hungary

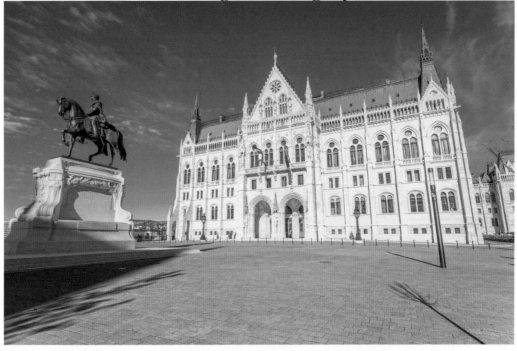

Entrance of Hungary Parliament, Budapest

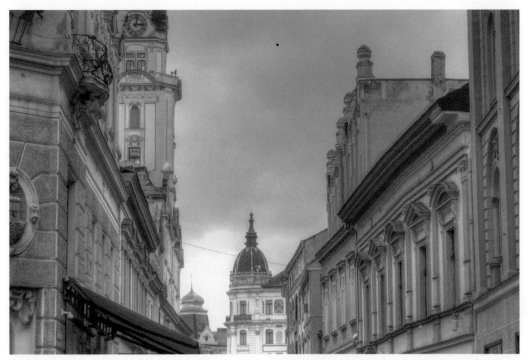

Pecs, Hungary

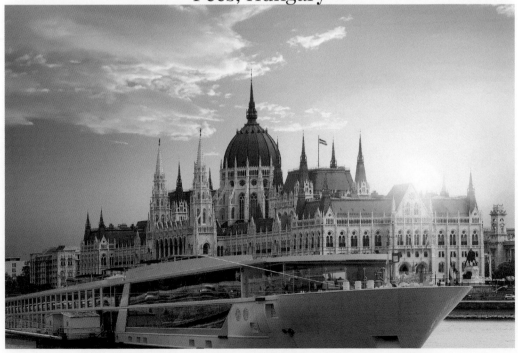

Tourist boat on Danube river, Hungary

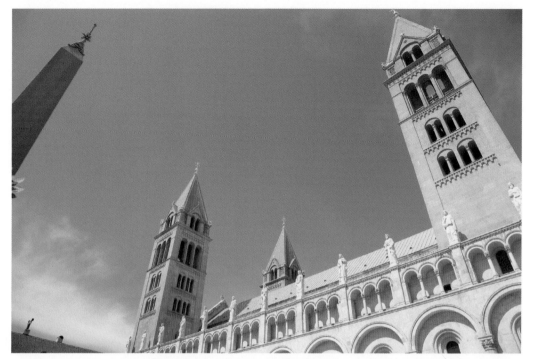

Basilica of St. peter and St. paul, Cathedral, Pecs Hungary

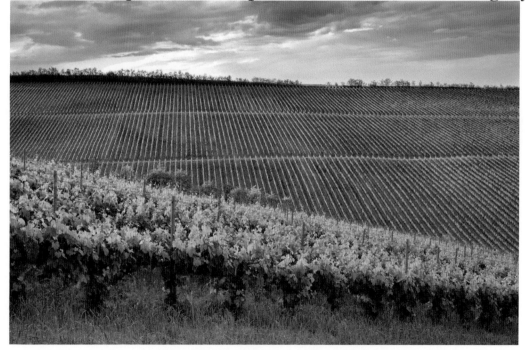

Vineyard, Villany Hungary

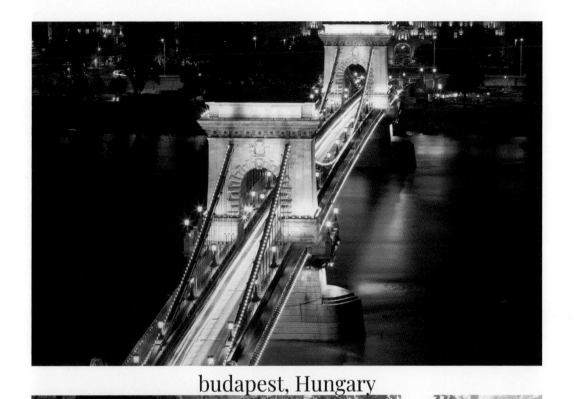

budapest, Hungary

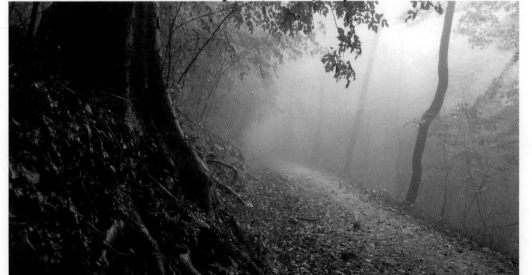

Forest at Urom, Hungary

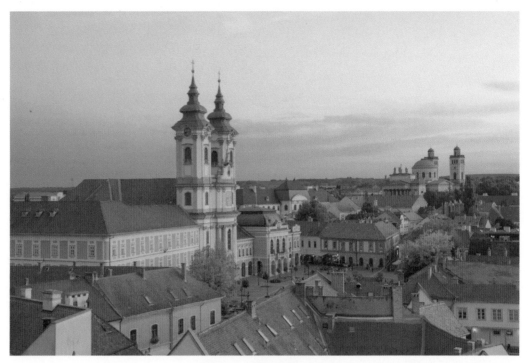

Eger, Hungary

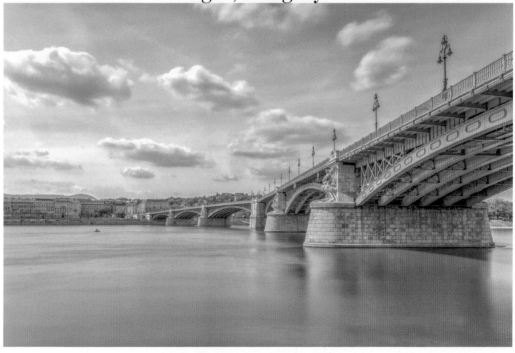

Budapest, Hungary

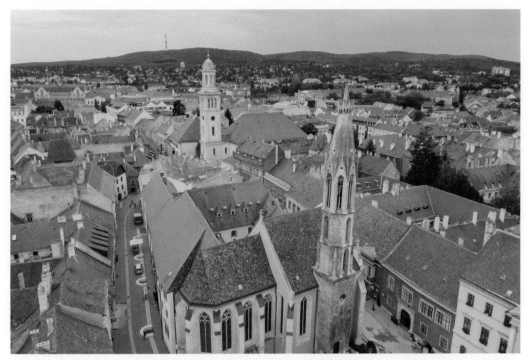

Rooftops of Sopron, Hungary

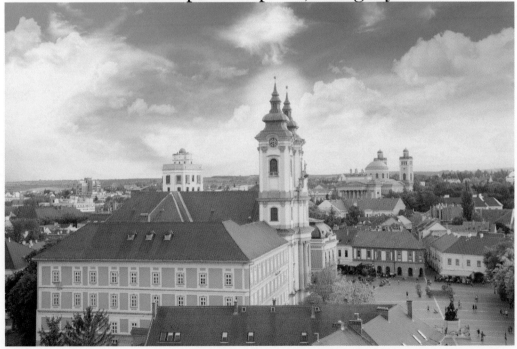

Eger, Hungary

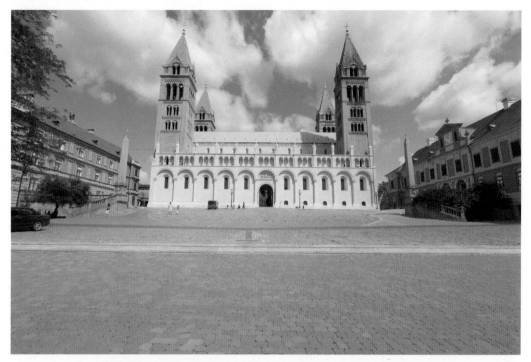

Cathedral church in Pecs Hungary

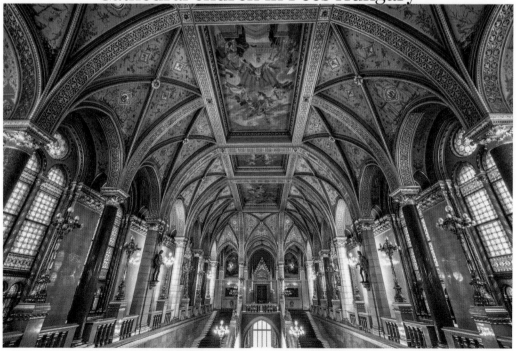

Interior of Hungary Parliament, Budapest

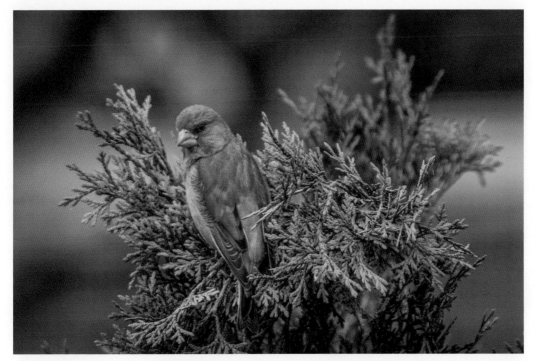

Bird in Heves, Hungary

Small village of Holloko, Hungary

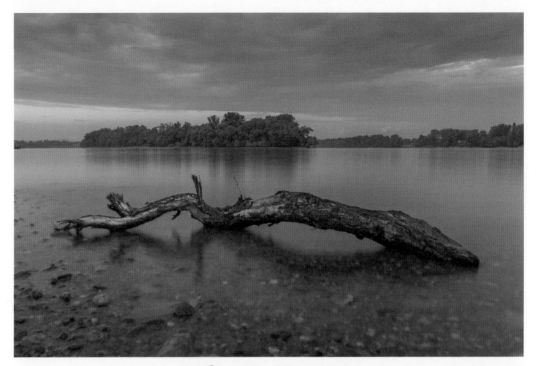

Budapest, Hungary

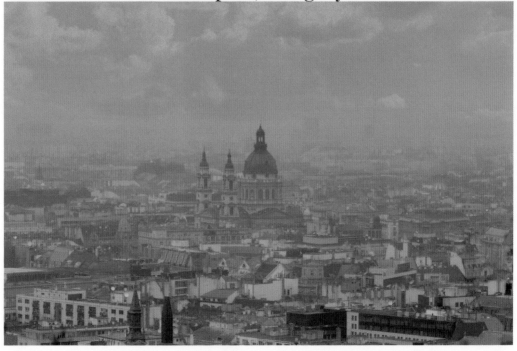

St. Stephen's Basilica, Budapest Hungary

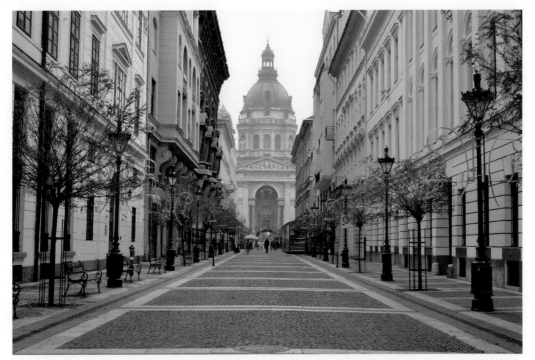

Streets of Budapest, Hungary

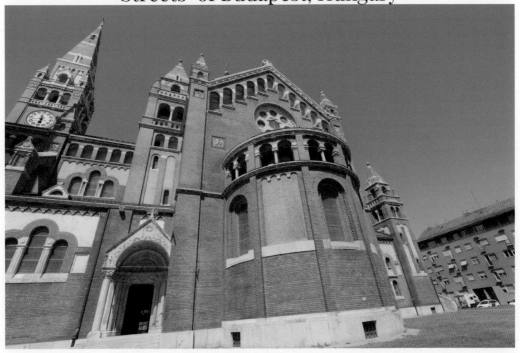

Votive church, Szeged, Hungary

Petal in Szodliget, Hungary

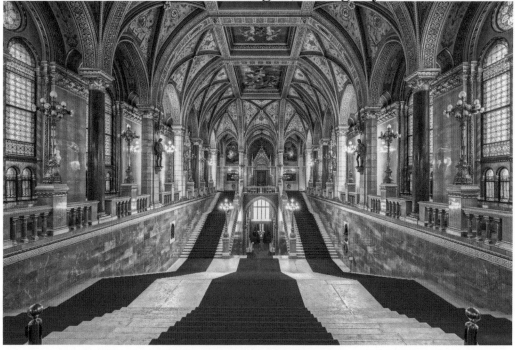

Interior of Hungary Parliament, Budapest

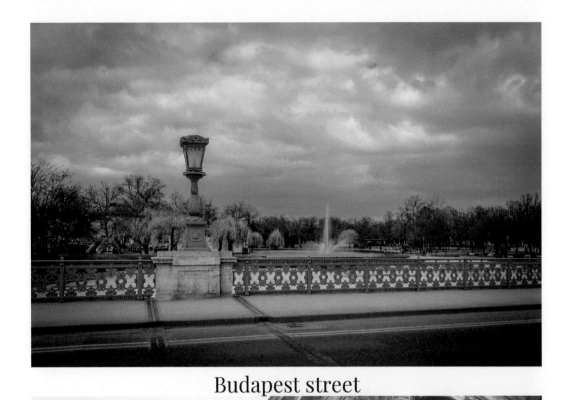

Budapest street

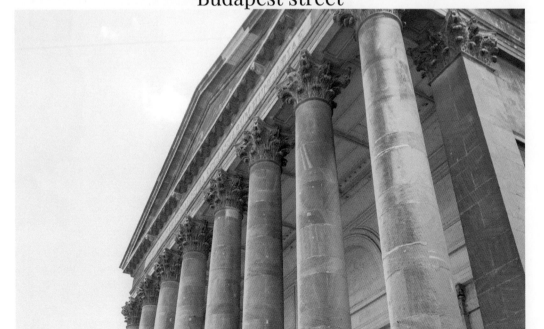

Basilica of Esztergom, Budapest Hungary

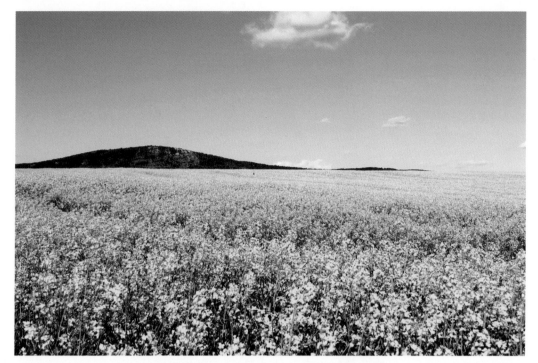

Field in Solymar, Hungary

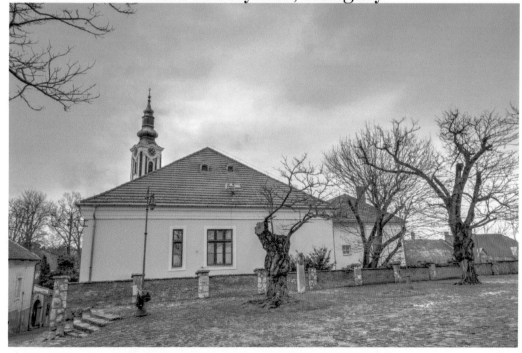

House in Szentendre. Hungary

Landscape of Lake Balaton, Hungary

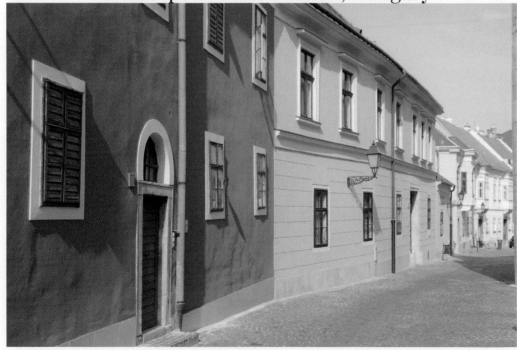

Street of Gyor Hungary

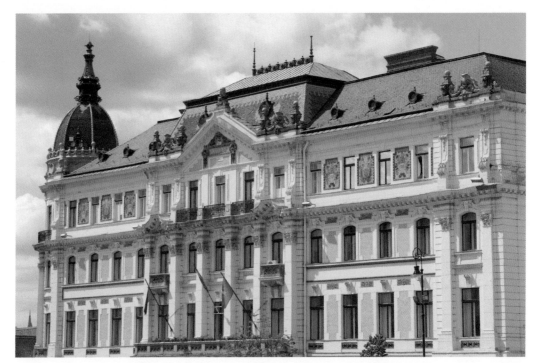

the county hall, Pecs Hungary

Hernad, Hungary

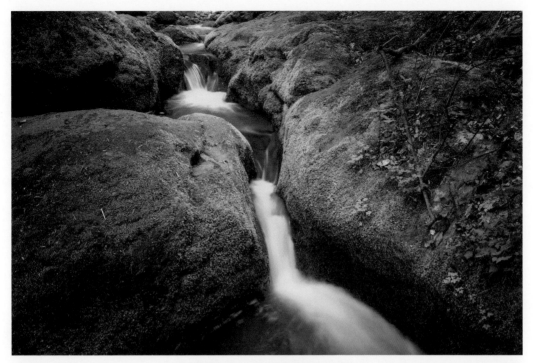

Visegrad, Hungary

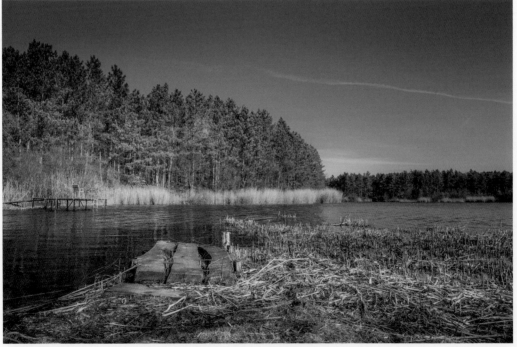

Petfurdo, Hungary

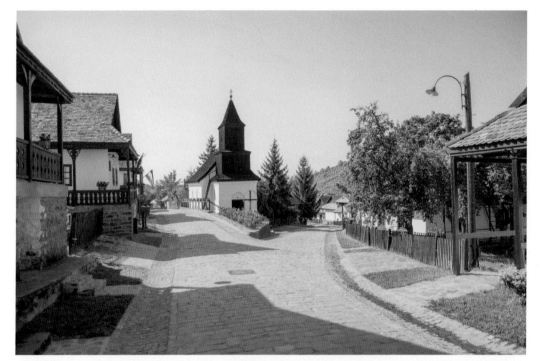

Holloko Village, Hungary

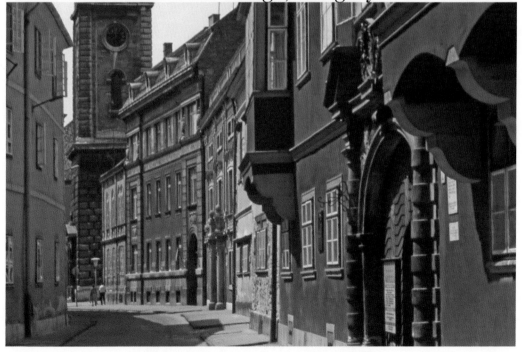

Street in Sopron Hungary

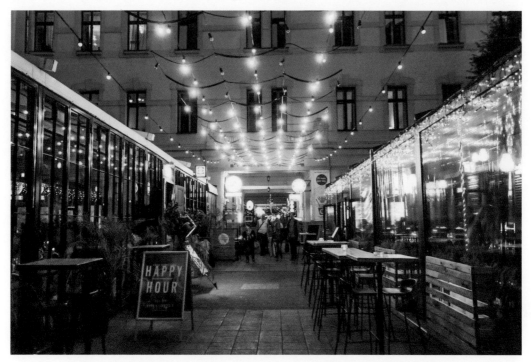

The Gozsdu Courtyard, Budapest Hungary

Field in Dorog, Hungary

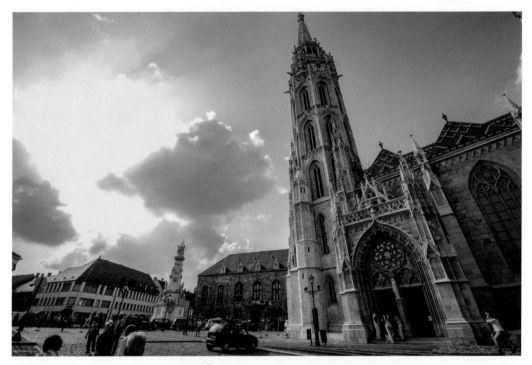

Budapest, Hungary

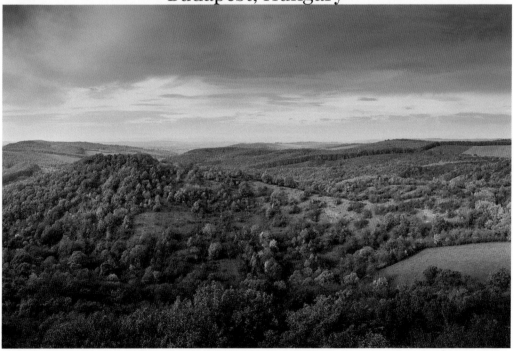

Rimoc, Hungary

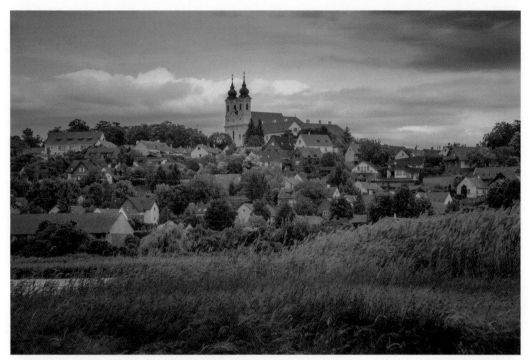

Tihany, Hungary

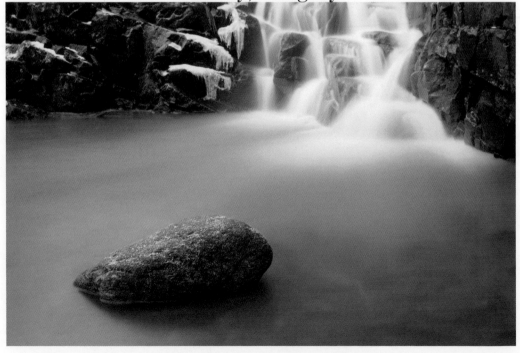

Nagykovacsi, Hungary

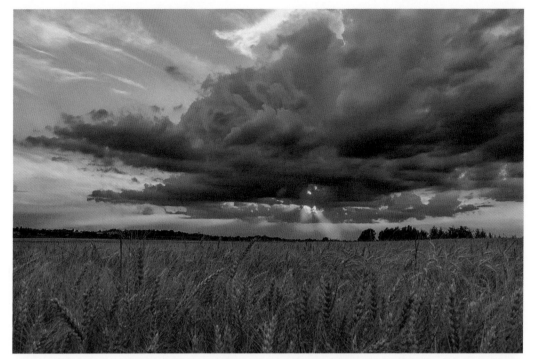

Gyorujbarat, Hungary

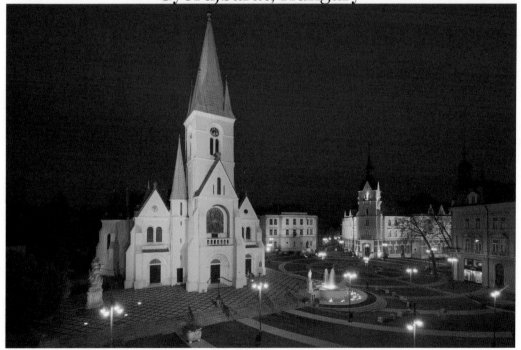

Kaposvar main square, Hungary

Printed in Great Britain
by Amazon

21918184R00030